Wildlife Photographer of the Year

Highlights volume 10

Published by the Natural History Museum, London

First published by the Natural History Museum, Cromwell Road,
London SW7 5BD

ISBN 978 0 565 0 95659

A catalogue record for this book is available from the British Library.

10 9 8 7 6 5 4 3 2 1

Design Bobby Birchall, BobbyandCo.com
Image Grading Stephen Johnson www.copyrightimage.com
Colour reproduction Saxon Digital Services UK
Printing L.E.G.O. S.p.A, Italy

Front cover Twist and jump, Jose Manuel Grandío, Spain
Winter is Jose's favourite season for photography. And it seems he's not the
only one enjoying this crisp February morning in the French Alps. His portrait
of a stoat (also known as a Eurasian ermine), caught in mid-air while hurling
itself about in a fresh fall of snow, clearly shows this excitement.
Nikon D500 + 500mm f4 lens; 1/6000 at f4; ISO 800.

Contents

Foreword

Henri Cartier-Bresson said, 'It is an illusion that photos are made with the camera... they are made with the eye, heart, and mind.' As we celebrate the 60th anniversary of the Wildlife Photographer of the Year competition, these words speak eloquently to the commitment and talent of the many photographers who have been a part of this community through the decades. And, when it comes to conservation and wildlife photography, I would add that it also takes a deep knowledge of the natural world and a willingness to invest time, sweat and occasionally tears in the pursuit of an image. Reaching 60 years of Wildlife Photographer of the Year also speaks volumes when it comes to the support of the Natural History Museum; their belief in the power of photography to educate, delight and hopefully inspire their worldwide audience is core to the overall success of the competition.

My initial encounter with Wildlife Photographer of the Year was in 2001, several weeks after 9/11. I was the Senior Editor for natural history and conservation storytelling at *National Geographic* and I had received my first invitation to the awards ceremony. I wasn't sure that travel would be possible, but there I was, in the Museum, seated under Dippy the dinosaur's tail. After the trauma of the past month, nothing could have prepared me for the restorative magic of that evening. The photographs were memorable, the energy was palpable and I was hooked. It was a reminder of the power of photography, of how images can create a shared moment, a collective memory. Over the past 23 years I have evolved from ardent supporter to occasional jury member and now Chair. It has been an honour to be involved with the competition and to be astonished, year after year, by the winning photographs.

Meanwhile, the competition, like the natural world, has also evolved. What began as a magazine contest, focused on providing a platform for photographers interested in wildlife photography, is now the premier contest for anyone pursuing wildlife and conservation imagery. The categories have come to reflect the pressing issues that photographers want to share.

Perhaps no photograph signalled that change more than Brent Stirton's 2017 win for Memorial to a Species. Brent's haunting image of a dead, dehorned rhino underscored the Natural History Museum's commitment to sharing what was happening in the natural world, the beauty and the horror. While fangs, feathers and fins still delight, increasingly, different species have taken centre stage. From Bao Yongqing's (2019) image of a Tibetan fox and marmot, to Karine Aigner's (2022) bee ball, to Laurent Ballesta's (2023) horseshoe crab, and now this year's winning image of western toad tadpoles by Shane Gross, photographers are making compelling photographs across all categories.

60 years of Wildlife Photographer of the Year – with finalists this year from 23 countries – also speaks to hope. Photographers want their work to spark awe and, when necessary, change. National parks have been founded thanks to photography, wildlife protection laws passed and climate regulations enacted. Change is possible and it starts with Wildlife Photographer of the Year.

KATHY MORAN
Chair of the Jury

Wildlife Photographer of the Year

Anniversaries are a time for reflection as well as celebration, more so when there is 60 years to commemorate. As is the case with Wildlife Photographer of the Year. To be selected as one of the final 100 images is a major achievement for any photographer; to be named a category winner is a career highlight. But the greatest accolades – the grand-titles of Wildlife Photographer of the Year and Young Wildlife Photographer of the Year – are the stuff of dreams.

A large part of the reason for the competition's enduring success is that anyone can enter, professional and non-professional alike, from anywhere in the world. In recent years, the competition's organizer, the Natural History Museum, has taken important steps to make Wildlife Photographer of the Year more accessible by introducing free entry for anyone aged 17 or under, or from more than 100 countries where the cost of entering might be prohibitive. The intention has always been to attract as many entrants as possible, to ensure that the competition continues to showcase the greatest variety of wildlife photography as well as the very best. This year, 59,228 entries from 117 countries were submitted.

Over its 60-year life, the competition has evolved into a major international platform highlighting the incredible and diverse wonders of our natural world through the powerful medium of photography. The exhibition, which opens in October at the Natural History Museum (immediately after the awards ceremony), now tours to over 35 venues globally. Adding to the excitement is the global reach through digital platforms, social media feeds and print publications. With such popularity, as well as photography's established potential for providing educational insight and influence, there is no better means for any photographer to amaze the world with their work than by taking part. The proof is in the images of the past 60 years.

The competition opens in mid-October and closes in early December. See *www.wildlifephotographeroftheyear.com*

Judges

Luciano Candisani (Brazil), photographer and cinematographer

Dr Paula Kahumbu (Kenya), storyteller, ecologist and wildlife conservationist

Rosamund (Roz) Kidman Cox OBE (UK), editor, photo editor and writer

Chien Lee (Malaysia), wildlife photographer and biologist

Miranda Lowe CBE (UK), Principal Curator of Crustacea and Cnidaria, Natural History Museum

Tony Wu (Japan), photonaturalist

Chair: Kathy Moran (USA), editor

The Wildlife Photographer of the Year 2024 Award

The grand-title award goes to Shane Gross, whose picture was judged to be the most striking and memorable of all the category winners. The picture is also the category winner of Wetlands: The Bigger Picture.

Shane Gross

CANADA

The swarm of life

On Canada's Vancouver Island, the waters of a mountain lake begin to swarm with millions of western toad tadpoles, rising from the depths towards the shallows to feed on surface algae. Shane snorkelled for several hours to photograph this spectacle, which could only be seen by diving beneath the thick carpet of lily pads covering much of the lake's surface. Female western toads lay up to 12,000 eggs in a single clutch, but an estimated 99 per cent of the tadpoles will not survive to adulthood. Yet, for one warm afternoon in July, these tiny-tailed, bean-shaped swimmers cover everything in sight, filling the pristine waters with life and hope.

Nikon D500 + Tokina fisheye 10–17mm f3.5–4.5 lens at 11mm; 1/200 at f13; ISO 640; 2x Sea & Sea strobes; Aquatica housing.

About the Photographer

A marine conservation photojournalist, Shane is the co-founder of the Canadian Conservation Photographers Collective. His passion for underwater photography was spawned by a childhood interest in sharks and family trips to the Bahamas, where he became a certified scuba diver and instructor. Shane is an associate fellow of the International League of Conservation Photographers.

A highly original and truly wondrous picture. It's a glimpse into a freshwater world bursting with life, with a palpable sense of energy as hundreds of tadpoles speed past and upwards towards the light – a migration that seems like a celebration.

Roz Kidman Cox

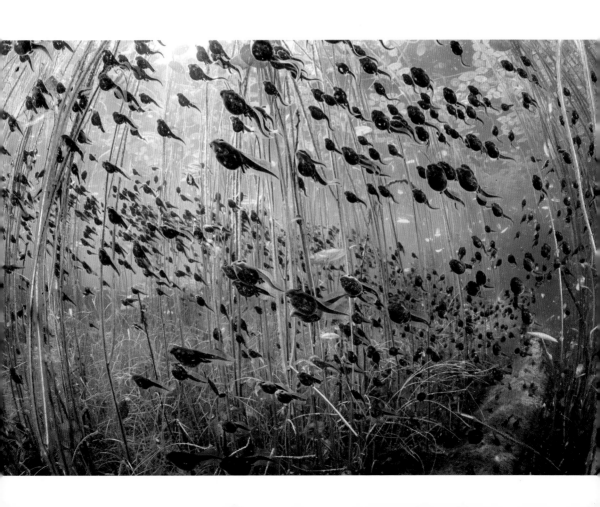

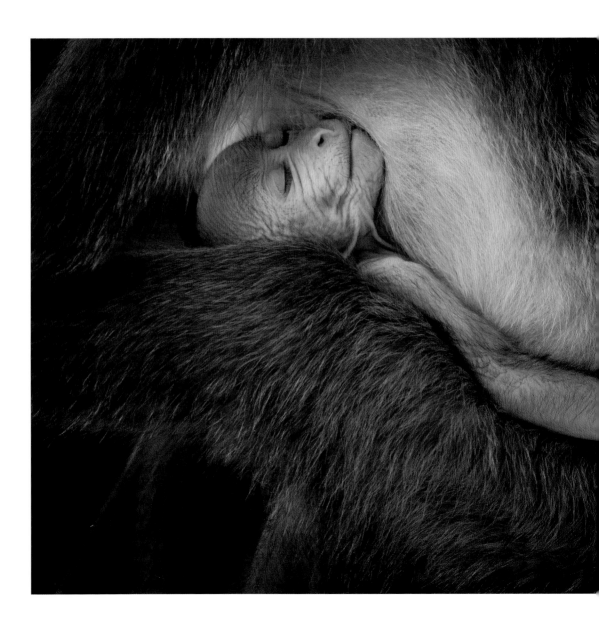

In this photograph, the design and subtle light contribute to a beautiful interpretation of a remarkable behaviour among primates – the mother's care for her offspring. It's the very translation of the beauty of motherhood.

Luciano Candisani

A tranquil moment

Hikkaduwa Liyanage Prasantha Vinod
SRI LANKA

It was breakfast time in Wilpattu National Park in northwest Sri Lanka, and not only for this infant toque macaque, suckling between dozes on its mother's chest. Vinod was visiting the park with his family – his wife and their two teenage children, who are both budding wildlife photographers. Having started the day photographing birds and leopards in the early morning light, they sought out a quiet spot to enjoy some refreshments in the shade. They soon realized they were not alone – a troop of toque macaques was picking its way through the trees above. Endemic to Sri Lanka, toque macaques are easily recognized by the characteristic mop of reddish hair sprouting from the top of the head, which gives them their name – a toque is a brimless cap once fashionable in Europe. Not wishing to disrupt such a tranquil moment between the mother and baby, Vinod carefully and quietly framed this composition using his long telephoto lens. Toque macaques aren't always viewed with such respect – though listed as endangered, they have no legal protection and are considered a pest species in Sri Lanka. In human-monkey conflict situations, people are at liberty to kill these primates. In a country that has lost more than 50 per cent of its forest cover in the past 70 years, this resting arboreal infant faces a challenging future.

Nikon D500 + 600mm f4 lens; 1/1250 at f4; ISO 3200.

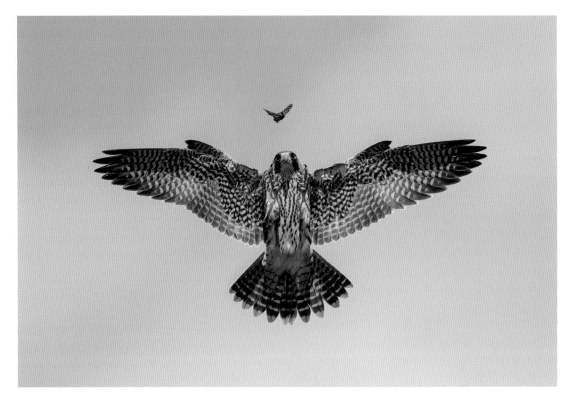

Practice makes perfect

Jack Zhi

USA

Should this juvenile peregrine falcon make it to adulthood, it will be chasing down avian prey and snatching it from the sky faster than any other animal on Earth. In tests, some peregrine falcons have reached speeds greater than 300 kilometres per hour (186 miles per hour) while diving on their prey. This peregrine already looks the part – eyes, beak and talons all converging on its quarry – but for now it is honing its skills by chasing butterflies. Jack was photographing the young falcon's antics from the top of a sea-cliff near Los Angeles, California. On a ledge below was the nest from which the youngster and its two siblings had fledged a little over a week before.

Sony α9 II + 600mm f4 lens; 1/4000 at f5.6; ISO 640.

The outstretched wings, the gaze, the incongruity of this predator chasing a butterfly all demand a second look. Beautifully composed and beautifully seen.

Kathy Moran

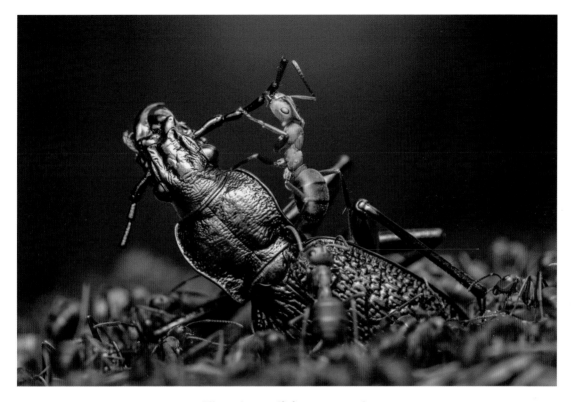

The demolition squad

Ingo Arndt
GERMANY

The stark red of the protagonist juxtaposed with the blue and green of the beetle and background pulls me directly into the heart of the action. I can feel – almost hear – the energy of the swarm while I marvel at the single-minded dedication of the lone ant scaling the summit of the beetle.

Tony Wu

This blue ground beetle was already dead when Ingo spotted it being carried by a group of worker ants to one of about 100 huge, domed nests packed into a few hectares of woodland in Hessen, Germany. He watched as the red wood ants set about carving it into pieces small enough to fit through the entrance holes. Much of the ants' nourishment comes from the sweet honeydew secreted by sap-sucking aphids, but they also need protein, which they get by scavenging dead animals and hunting live ones. As Ingo's photograph testifies, the grim realities of nature can be spectacular when seen through a camera lens.

Canon EOS 5DS R + 100mm f2.8 lens; 1/200 at f8; ISO 400; Canon Macro Twin Lite MT-24EX flash; softboxes.

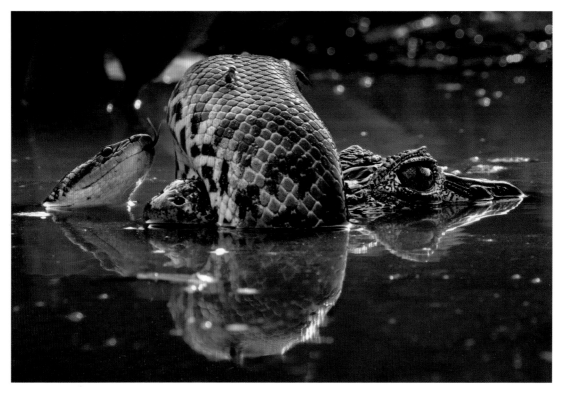

Wetland wrestle

Karine Aigner

USA

A seemingly impregnable object meets an irresistible force. Karine was leading a tour group of intrepid photographers along a single-track road raised above flooded terrain, in the wetlands of the Brazilian Pantanal, when she noticed a yellow anaconda had wrapped its coils around the snout of a yacaré caiman. Over the next 20 minutes, Karine watched repeated bursts of mutual struggle as the pair thrashed around violently. The resolution was sudden and rather anticlimactic – after one last thrash of the water, the anaconda simply relaxed its grip and disappeared beneath the surface, while the caiman glided off into the vegetation.

Sony α1 + 200-600mm f5.6-6.3 lens: 1/400 at f16; ISO 800.

Despite the apparent life-or-death struggle between these two animals, this image is remarkable in capturing a seemingly peaceful moment – the still water with reflections, the two opponents staring, the snake taking time to taste the air with its tongue. Indeed, it seems difficult to distinguish predator from prey.

Chien Lee

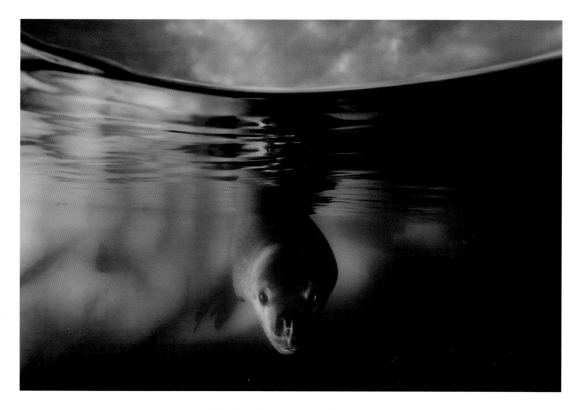

Under the waterline

Matthew Smith
UK/AUSTRALIA

In this impressive portrait of one of the most interesting creatures of the cold seas, the dramatic atmosphere formed by the dark sky and the faint light of the underwater part take the eye directly to the centre of interest of the image and keeps it there. It's an intriguing and mysterious image.

Luciano Candisani

There was an unexpected welcome for Matthew and his fellow photographers as their yacht pulled into Paradise Bay on the Antarctic Peninsula. It was late in the day and Matthew had to work quickly in the fading light. He quietly slipped into the water with his camera. This was his first encounter with a leopard seal, a formidable predator of penguins, squid and other young seal species. Attacks on people are rare, but Matthew didn't want to push any boundaries, so he floated next to a chunk of surface ice and waited for the seal to approach him.

Nikon Z7 II + 14-30mm f4 lens; 1/200 at f11; ISO 640; neutral density graduated filter; Aquatica AZ6/7 housing + Matty Smith 12in split shot dome port; Sea & Sea YS-D3 MKII strobes.

Tiger in town

Robin Darius Conz

GERMANY

A female Bengal tiger relaxes on a hillside as dusk falls in the Nilgiris district of the Western Ghats, a large mountain range in southern India. Behind her, the lights and roofs of a small town fill the background slopes where forests would once have grown. Robin was following the tiger as part of a documentary team that has been filming the wildlife of this region for the past two years. With his airborne drone, Robin watched the tiger settle in this spot and constantly monitored her body language to make sure he was not disturbing her. Though the overall tiger population in India has been increasing steadily since the mid-2000s, the situation in the Western Ghats is less promising. Habitat loss, poaching and human-wildlife conflict remain the main threats to tiger populations here, as they do throughout India. Conservationists say the quality of habitat and quantity of prey outside of protected areas is not sufficient to prevent tigers from venturing into human-dominated landscapes, such as here in the Nilgiris district, to hunt cattle and other farmed animals. Despite recent reported increases, India's tigers remain endangered and must continue to adapt to the country's fast-changing landscape to survive.

DJI Mavic 3 Pro Cine + 70mm f2.8 lens; 1/15 at f2.8; ISO 400.

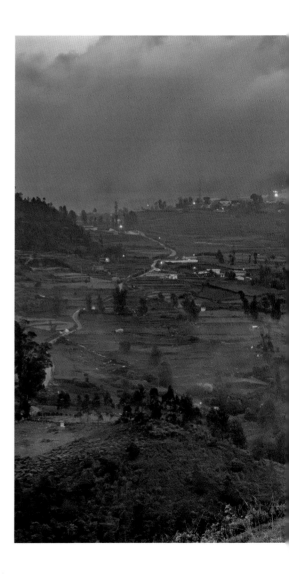

A hauntingly symbolic image that sums up in a single frame the problems facing tigers in today's world. A once-forested landscape is now occupied by humans, their houses, fires and crops, offering nothing in the way of food except a chance domestic animal. There's no place for tigers here.

Roz Kidman Cox

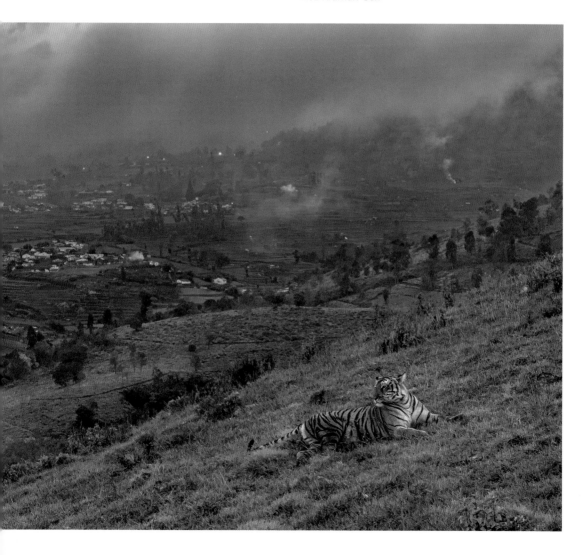

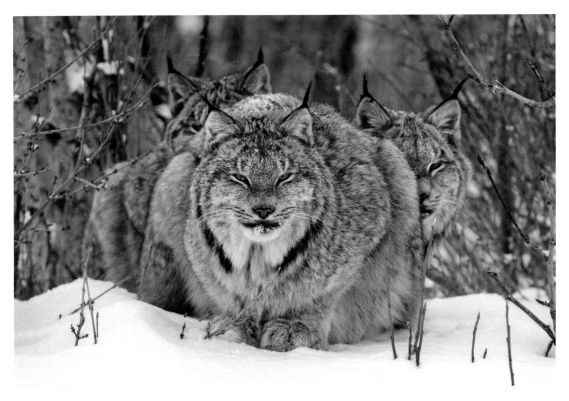

On watch

John E. Marriott

CANADA

Perfectly camouflaged against the edge of a willow stand, an adult lynx and her fully-grown young rest after a hunt. John had been tracking them for almost a week, wearing snowshoes and carrying light camera gear to make his way through the snowy forests in Canada's Yukon territory. These medium-sized cats live in the dense forests of Canada and Alaska. When fresh tracks led to this family group, John kept his distance to make sure he didn't disturb them. He spent five minutes taking photographs, then slowly backed away. It was an hour before nightfall and -20°C (-4°F), with the kittens sheltered from the cold wind behind their mother.

Canon EOS 5D Mark IV + 100–400mm f4.5–5.6 lens at 400mm; 1/800 at f9; ISO 1250.

The almost seamless way these lynxes blend in with their background makes it difficult to perceive at first glance that there are three animals present. The engaging yet relaxed gaze from the front lynx combined with the gentle lighting work together to make this a memorable portrait.

Chien Lee

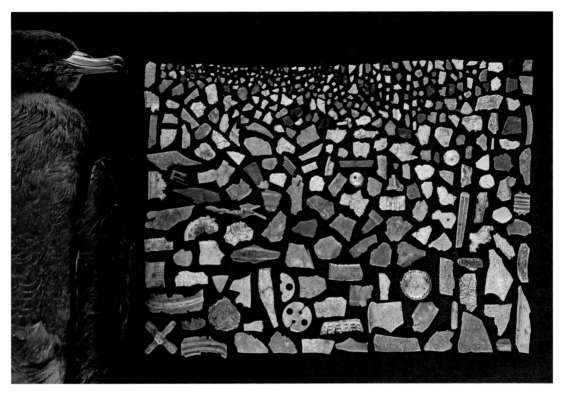

A diet of deadly plastic

Justin Gilligan
AUSTRALIA

As the tragic fate of this bird shows, plastics – which do not exist in nature – penetrate even the most remote corners of the planet. It's arguably not an exaggeration to say that the sea is a soup of plastic, one that grows thicker by the minute.

Tony Wu

This mosaic of shapes and colours looks innocuous enough, until you realize that it is composed of 403 pieces of plastic that were removed from the digestive tract of a flesh-footed shearwater. The dead seabird washed up on the shore of Lord Howe Island, off the east coast of Australia. The grim discovery was made by researchers at the island's Adrift Lab, a group that brings together biologists from around the world to study the impacts of plastic pollution on marine ecosystems. Flesh-footed shearwaters forage for fish and squid across the Pacific and Indian oceans but are accidentally ingesting floating plastic in huge quantities, which they then feed to their chicks.

Nikon D850 + 24–70mm f2.8 lens; 1/125 at f11; ISO 400; Profoto B10 + A1 flash.

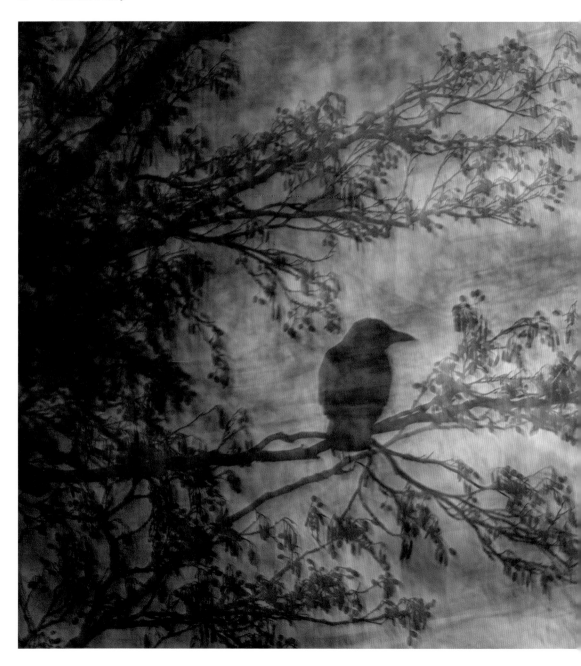

Elegant and haunting are the words that come to mind when I look at this photograph. The movement is just enough to give it an edge, but not enough to take away from the mood created by the light and the perfect placement of the bird.

Kathy Moran

The artful crow

Jiří Hřebíček

CZECH REPUBLIC

A carrion crow settles on an alder tree in a city park. It could be an everyday scene not warranting further attention if it wasn't for the painterly, almost Impressionistic interpretation of this common-place species found throughout western Europe. As well as city parks, carrion crows thrive in open country, including farmland, gardens and forest clearings, wherever there are tall trees to roost and good views of their surroundings. Jiří is a passionate bird photographer and more used to photographing their movement in flight; but for this image it was the bird that kept still and not the camera. To create this effect, he deliberately moved his camera in different directions while using a long shutter speed – a method known as 'intentional camera movement', a particularly effective technique for static subjects. Jiří's local park in Basel, northern Switzerland, was an ideal place to experiment, especially in winter when large flocks of carrion crows arrive to roost in the treetops overnight. Though their diet includes earthworms, frogs and bird eggs, they primarily scavenge for carrion, as their name suggests, patrolling for roadkill and mobbing other birds for their catch.

Canon EOS 5D Mark IV + 70-200mm f2.8 lens + 2x teleconverter; 2 sec at f10; ISO 50; variable neutral density filter.

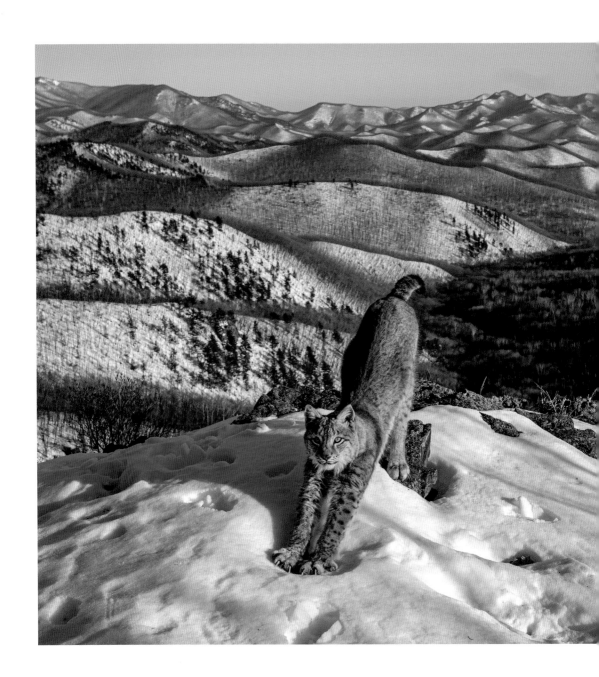

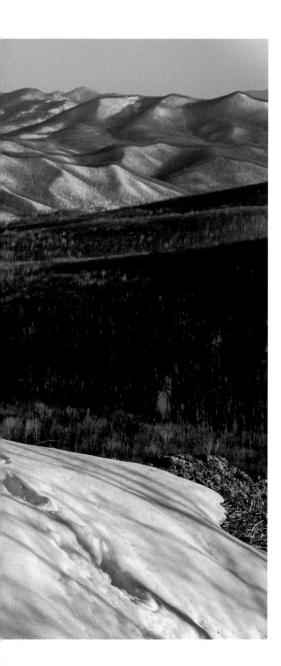

What a landscape – vast and wild – and what a vantage point to survey from. Few humans will ever step here, let alone set up a camera trap. The delight of the image comes from the relaxed stretch of the Amur lynx, staring nonchalantly at the camera.

Roz Kidman Cox

Frontier of the lynx

Igor Metelskiy
RUSSIA

In early evening sunshine, an Amur lynx stretches, the colour and line of its body blending with the undulating background hills of its remote wilderness home in Primorsky Krai, in the Russian Far East. When setting up his camera trap, Igor found nearby footprints of a sika deer and droppings from a long-tailed goral, both indicators of the presence of this medium-sized carnivore's habitual prey. It took more than six months of waiting to get this result of a calm and relaxed predator stretching on a snow-clad vantage point to reveal the sharp claws that are usually hidden in the folds of its paws. But this subspecies of the Eurasian lynx still needs to remain wary in this vast frontier. Larger predators, including Amur tigers, Amur leopards and brown and Asiatic black bears, also inhabit these forests. On one occasion, while out checking his camera traps, he realized that he and his companion had been watched by an unseen tiger that was hidden behind a spruce tree just 14 metres (46 feet) away – that's two tiger leaps. To add to the animal's mystique, its classification of Amur lynx isn't entirely agreed by scientists: Russian scientists regard it as a separate subspecies and IUCN as needing investigation.

Sony α7 IV + 24-70mm f2.8 lens; 1/500 at f/5.6; ISO 100; Scout camera controller + PIR motion sensor.

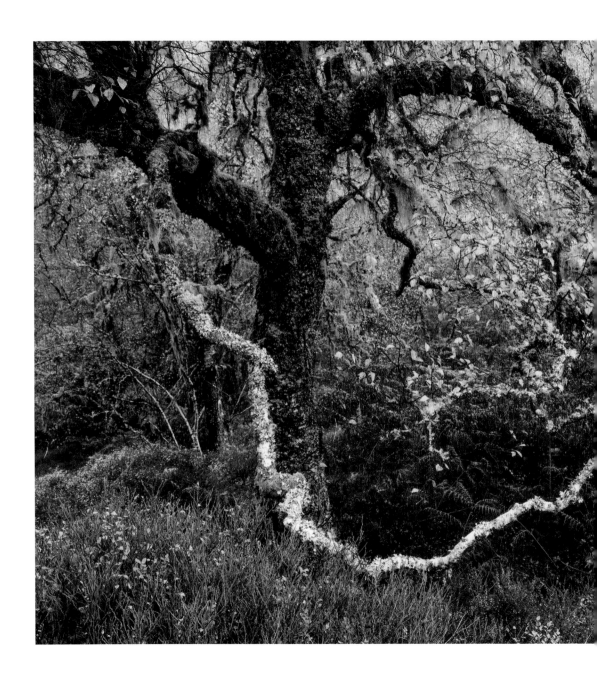

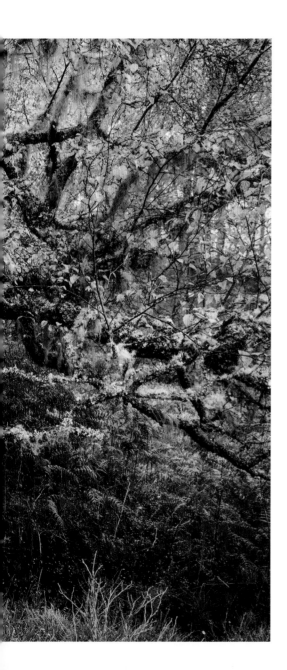

The composition, the soft colours, the curl of the branches made me feel as if I was in an enchanted forest. So often this category focuses on smaller species or individual plants and fungi. It was a nice surprise to step back and consider the larger environment.

Kathy Moran

Old man of the glen

Fortunato Gatto

ITALY

For all its crumbling castles and historic battle sites, Scotland is a young country in ecological terms. During the Pleistocene, ice scoured all life from the land. Only once the glaciers retreated 11,500 years ago could flora and fauna begin their regeneration. Evolution has had little time to work its magic here and Scotland has few endemic species, but Glen Affric is significant because it is home to the highest concentration of native trees in the UK, making it a vital ecosystem. Analysis of pollen preserved in the layered sediments shows that the forest has stood here for at least 8,300 years. For centuries after the last ice age ended, 70 per cent of Scotland was covered by Caledonian forest. Most of this great forest was gradually felled for firewood and timber, but a few fragments survive. Spanning about 48 kilometres (30 miles) of ancient pinewoods, Glen Affric (from the Gaelic for 'the glen of the dappled woodlands') is one of the largest surviving tracts of this once great forest – a place that Fortunato often visits alone, to lose himself in its intricate, chaotic and timeless beauty. And it was there he came across this gnarled, old birch tree, its trunk and branches adorned with pale 'old man's beard' lichens.

Canon EOS R5 + 24-105mm f4 lens; 4 sec at f13; ISO 320; remote shutter release; Leofoto tripod.

In this image, the composition of the opposing elements and the light create an atmosphere so intriguing and dramatic that it's almost impossible not to want to know more details about the story conveyed by the photograph. It's a great merit for any journalistic image.

Luciano Candisani

Dusting for new evidence

Britta Jaschinski

GERMANY/UK

Trying to find fingerprints on an elephant tusk used to be a futile exercise because ivory is porous and absorbs the prints in about 24 hours, making them impossible to retrieve using conventional techniques. But developmental work by Mark Moseley, a crime-scene investigator from London's Metropolitan Police, and Dr Leon Barron, a forensic expert from King's College London, led to the creation of a new magnetic powder that can lift fingerprints up to 28 days after a tusk has been handled by poachers. Here, Moseley is applying the powder to a confiscated tusk at the CITES Border Force Department at London's Heathrow Airport. Moseley worked in his spare time for several years developing the new forensic material, and the International Fund for Animal Welfare has since distributed more than 200 testing kits to border forces from 40 countries in Africa and Asia. The original trial kit proved instrumental in securing evidence in four cases in Kenya, resulting in 15 arrests, including five police officers, and the seizure of 11 elephant tusks. The kit has also been tested successfully on tiger claws, rhino horn, pangolin scales and other trafficked wildlife.

Leica SL2 + 24-90mm f2.8-4 lens at 62mm; 1/80 at f3.8; ISO 200.

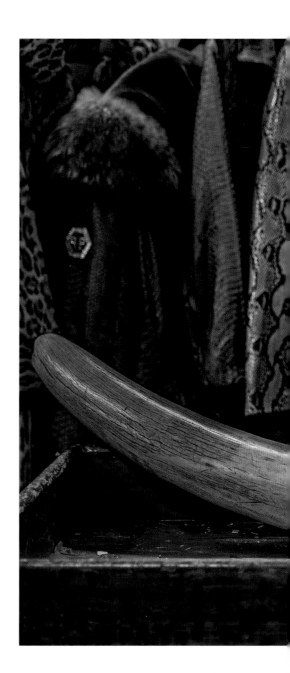

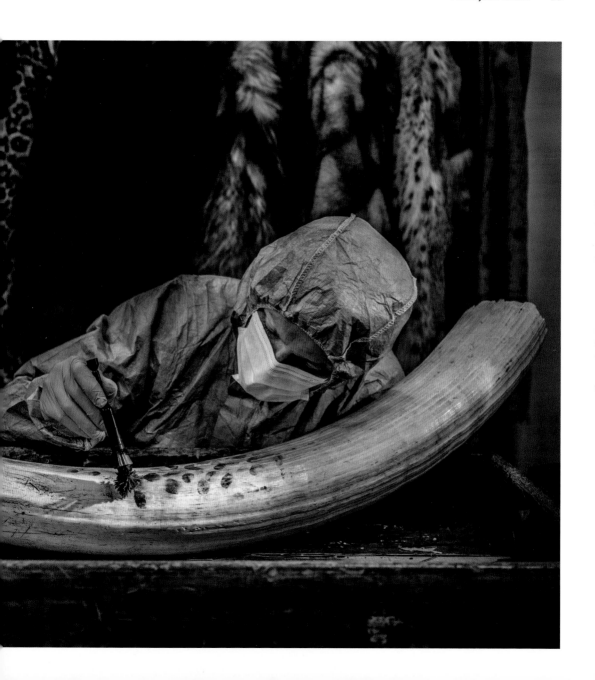

Photojournalist Story Award

The award is given for a story told in just six images, which are judged on their storytelling power as a whole as well as their individual quality.

Thomas Peschak
GERMANY/SOUTH AFRICA

Dolphins of the forest

Thomas Peschak's portfolio depicts the relationship between botos – also known as Amazon river dolphins – and the people with whom they share their watery home. Some view them as spirits who change into human form and invade their homes, others as thieves who steal fish from nets and deserve to pay for their larceny with their lives. Botos are also killed as bait to catch commercial fish. But there is a non-lethal way to make money out of these endangered cetaceans – Thomas took his pictures in areas where botos are utilized by local communities to create an experience for tourists. However, it brings another set of problems, with river dolphins becoming obese and some younger animals now unable to hunt for themselves, relying instead on handouts from their human admirers.

Among the trees

A boto explores a flooded forest just outside Anavilhanas National Park, upstream from Manaus in Brazil. The boto is one of two freshwater dolphin species that live in the Amazon and Orinoco Basins, but only this species has evolved to explore the seasonally flooded habitat. Unfused neck vertebrae – unlike all other whales and dolphins – allow botos to move their heads through a 180° arc and more easily navigate the forests floors littered with tree roots and other obstacles.

Nikon Z9 + 14-30mm f4 lens at 16mm; 1/320 at f6.3; ISO 1250.

Living within the murky waters of these flooded forests, the pink river dolphins are notoriously difficult to photograph. Within these six images, the photographer has not only been able to capture compelling glimpses of their underwater behaviour but also to show how their story is connected with that of the people of this region.

Chien Lee

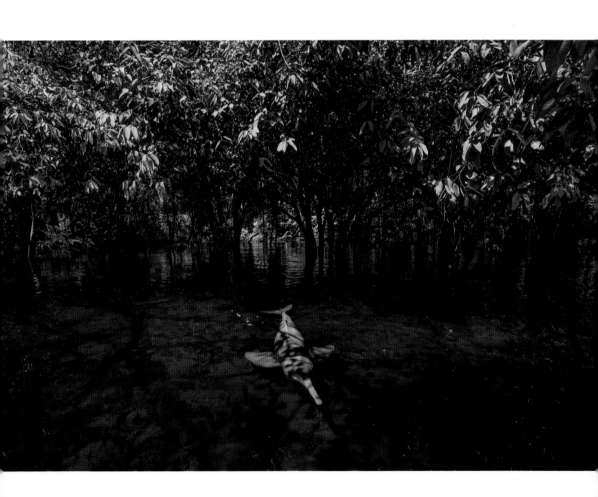

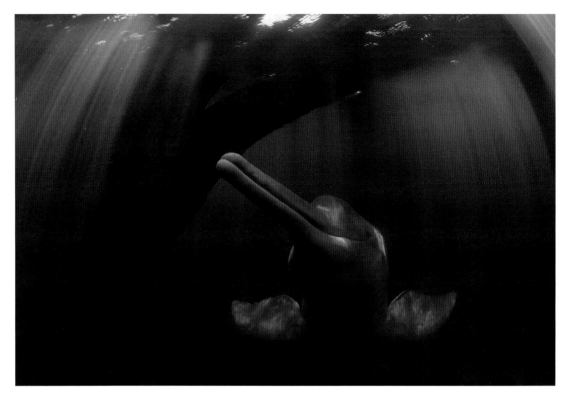

Underwater wings

A boto uses its sonar to navigate a path between tree trunks in a flooded forest, emitting a series of clicking noises, 30-80 per second, which bounce off obstacles and potential prey in the murky waters. They generate the sonar through their bulbous head, changing its shape at will to alter the frequency, volume and direction of the clicks. Botos also possess bristly hairs on their beaks, which work like whiskers in closer confines. Each time Thomas was in the water with these animals he was impressed by their ability to swim confidently at speed so close to unseen obstacles. Their wing-like pectoral fins are also critical to navigating this topographically complex environment. Botos are born grey, but as they age their flesh takes on an increasingly pink appearance, with the blood beneath the skin becoming more visible.

Nikon Z9 + 8-15mm f2.8 fisheye lens at 15mm; 1/80 at f10; ISO 2000, Nauticam underwater housing.

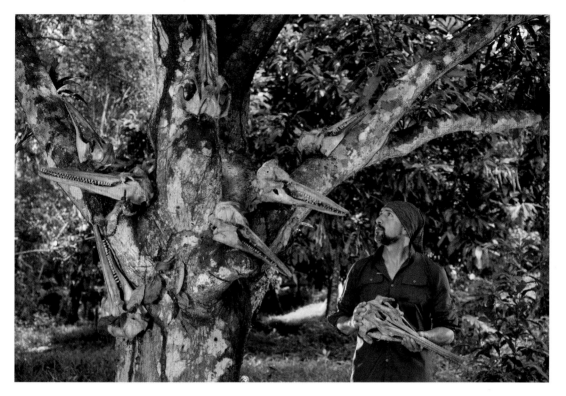

Tree of skulls

One of the world's foremost experts on botos, Dr Fernando Trujillo stands next to a tree with boto skulls from his research collection in the southeast Colombian Amazon. A comment by Trujillo provided Thomas with the inspiration for this photograph: 'He told me that once the rains begin, this entire landscape would soon be submerged by at least five metres (over 16 feet) of water. He said dolphins would then literally be swimming among the trees.' Trujillo is a vocal advocate for river dolphin conservation and helped coordinate the Global Declaration for River Dolphins that has been signed by most of the major range states in South America, as well as those in Asia where other river dolphin species are found. Male botos can grow to 2.7 metres (nearly nine feet) in length and weigh more than 200 kilogrammes (441 pounds), making them the largest of all river dolphins.

Nikon Z9 + 24-70mm f2.8 lens at 45mm; 1/200 at f4; ISO 100; 5x Profoto flashes.

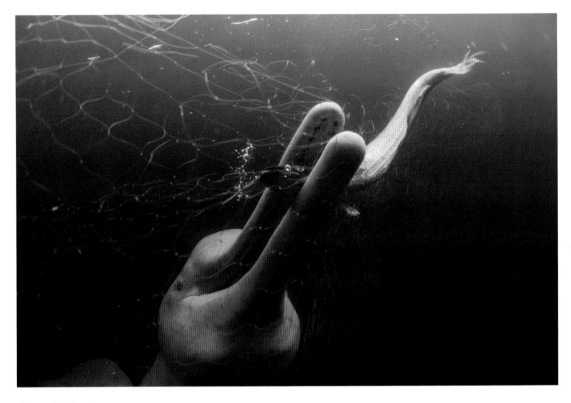

Caught in the act

A boto takes a catfish from a fisherman's net in the Rio Negro, Brazil. Here, the animals have learned to associate the sounds of fishing boats and nets with an easy meal, but some get entangled and drown. This photo, the result of a collaboration between Thomas and researcher Dr Mariana Paschoalini Frias, is the first time such behaviour has been visually documented, and could help conservationists devise strategies to reduce these incidents. Human conflict with river dolphins is a major issue in the Amazon and Orinoco Basins – one study in Peru found that 86 per cent of fishermen associated botos with negative economic impacts. Because fish are currency and nets are a considerable financial investment, botos are lambasted as thieves by fishermen and viewed as a threat to local food security.

Nikon Z9 + 8-15mm f2.8 fisheye lens at 15mm; 1/640 at f5; ISO 3200; Nauticam housing.

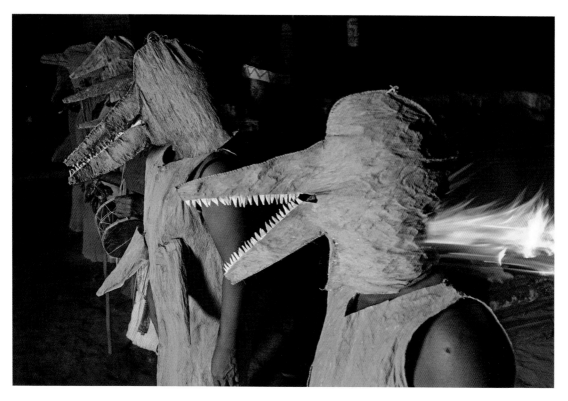

Creatures of the night

Botos are also known as pink river dolphins, and in southwest Colombia, village elders adorn pink costumes to dance around their long house while singing about the place and role of the boto in their world. The costumes are made from the bark of a fig tree, painted with vegetable dyes and designed to symbolize the original cosmic connection between the people and the environment. Many folk tales are attributed to botos, including their ability to transform into handsome young men who enter villages at night to seduce women. Another warns against swimming alone in the river or risk being taken by a dolphin to the magical underwater world of Encante. To make this intimate image, Thomas participated in the dance instead of photographing from the sidelines.

Nikon Z9 + 24–120mm f4 lens at 31.5mm; 0.4 at f7.1; ISO 1000; Profoto B1 flash.

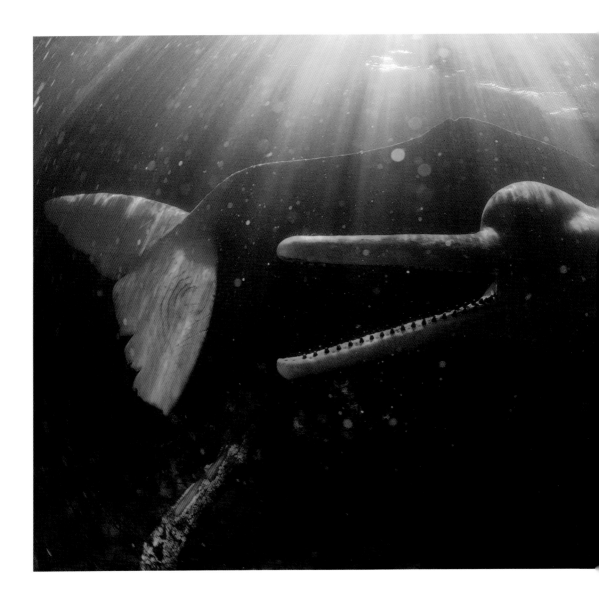

The hunter's teeth

A boto displays the numerous pairs of teeth that help make it one of the top predators of the Amazon basin's aquatic habitats. While other species of dolphin have undifferentiated, conical teeth in their upper and lower jaws, botos are unique in possessing molar-like teeth at the back of the jaw for crushing their prey. Botos feed on more than 40 species of fish, as well as turtles and crabs, which they grind with these back teeth before swallowing. Though their eyes are small, they are functional and give the boto better eyesight than other river dolphins. In some parts of Brazil and Colombia, local people have been feeding dolphins to create a potentially sustainable tourist business, but there are concerns that this is leading to increased assertiveness and aggression among the animals, which could compromise their welfare and result in injuries to unwitting tourists. Researchers are working at developing strategies to reduce these negative impacts.

Nikon Z9 + 8-15mm f2.8 fisheye lens at 15mm; 1/320 at f8; ISO 2000; Nauticam housing.

Rising Star
Portfolio Award

The award seeks to inspire and encourage photographers aged 18 to 26 and is given for a portfolio of work.

Sage Ono
USA

The Serengeti of the sea

Growing up in various land-locked US states, Sage was hardly destined to be an underwater photographer. But, inspired by the stories told by his grandfather, a retired marine biologist, and by a photograph of a larval cusk eel he saw when he was 16, Sage acquired a compact underwater camera and decided this was the life he wanted. His new home patch is the Monterey Bay National Marine Sanctuary on the central Californian coast, dubbed the 'Serengeti of the sea' in recognition of the 36 species of mammals found in its waters. But it's the submerged world of the bay's forests of giant kelp and the myriad life forms they contain that have captured Sage's imagination.

In this beautiful set of images, two things stand out: the innovative way of showing an already-known theme and the aesthetic identity that strongly links all the images. It's a portfolio with a lot of personality.
Luciano Candisani

Rubies and gold

Each of these clusters of glistening eggs was laid by a female tube-snout, one of 525 species of fish recorded in the Monterey Bay National Marine Sanctuary. Female tube-snouts string the clutches of eggs around the kelp, where the resident male guards them aggressively until they hatch. These freshly-laid eggs will gradually fade in colour as the embryos develop within. For now, they seem to sparkle like gemstones next to the kelp's glowing gold pneumatocysts (gas-filled buoyancy aids). The green serrated edges of the kelp fronds complete a simple composition where each element is in exactly the right place.

Nikon D850 + 60mm f2.8 lens; 1/160 at f14; ISO 250; Nauticam NA-D850 housing; 2x Sea & Sea YS-D2J strobes.

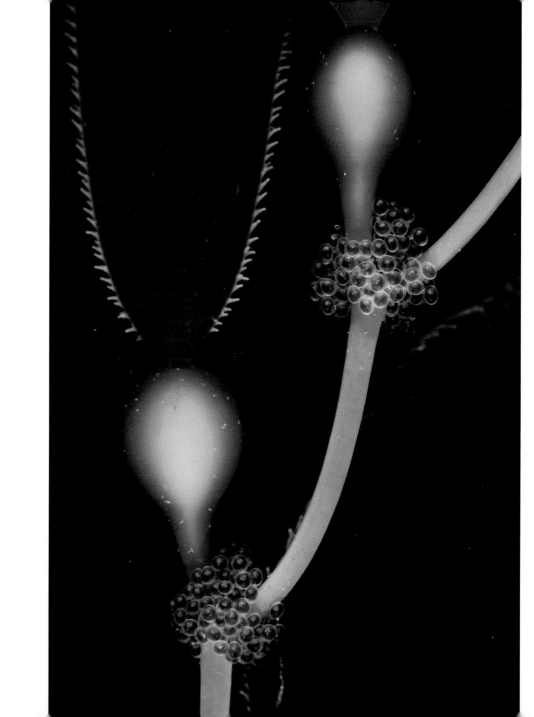

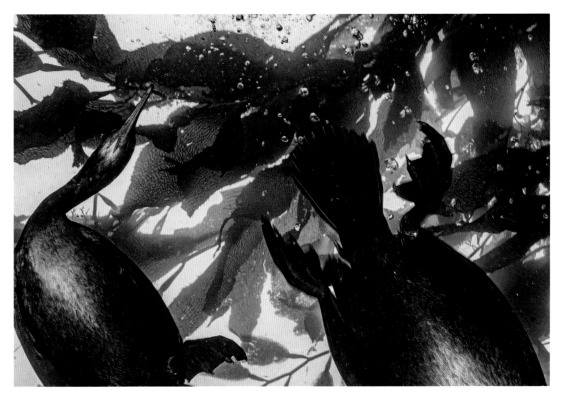

Curious cormorants

For most of the year, Brandt's cormorants keep their distance from divers in Monterey Bay. But in August, Sage becomes an object of curiosity for young birds that have recently fledged from nests on the rocky coastline. They nip at his mask and fins and at their own reflections in his camera housing. This is no time for complex photo compositions. Indeed, the unconventional framing and slight motion-blur contribute to the charm of this image, taken from below, showing two juveniles frolicking among the kelp. The largest cormorant on North America's Pacific coast, Brandt's are strictly marine and feed mainly on fish and squid. These fledglings will soon become expert divers, but for now, they are content exploring their immediate surroundings – and pecking at the odd intruder.

Nikon D850 + 16-35mm f4 lens; 1/200 at f13; ISO 200; Nauticam NA-D850 housing; 2x Sea & Sea YS-D2J strobes.

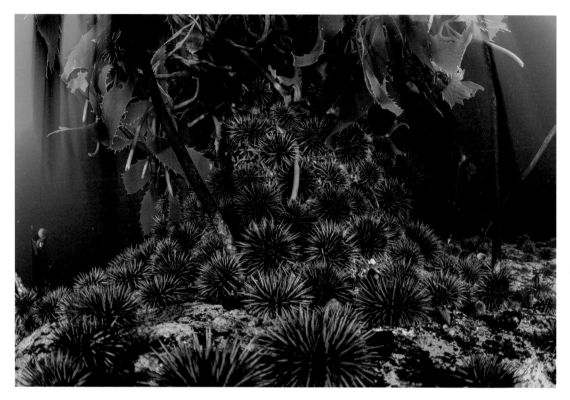

Purple patch

Monterey Bay's purple sea urchins have benefitted from the woes of another Californian echinoderm, the sunflower sea star, a major predator of the urchins until it was all but wiped out by a wasting disease that struck in 2014. The resulting explosion in urchin numbers has had a knock-on effect – these voracious grazers, together with a series of damaging marine heatwaves, have reduced kelp cover in the region by more than 80 per cent. The site of this photograph used to be known for giant kelp so thick it blocked out the sun, but when Sage swam down he found hordes of purple urchins chewing through what was left. The survival of the kelp forests may depend on another predator of urchins – the California sea otter, which selectively feeds on healthy urchins within the bay's remaining kelp areas.

Nikon D850 + Tokina 10-17mm f3.5-4.5 lens; 1/3 at f18; ISO 160; Nauticam NA-D850 housing; 2x Sea & Sea YS-D2J strobes.

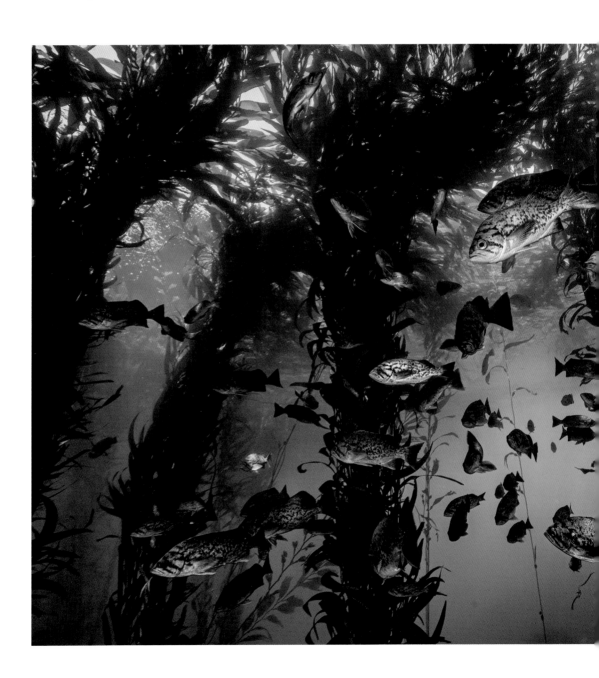

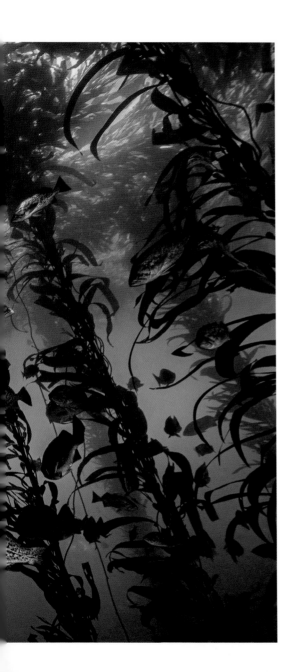

Underwater sanctuary

It may be an undersea forest, but Sage likes to think of these areas of giant kelp as a cathedral. The largest of all seaweeds can grow at least 45 metres (148 feet) high, able to anchor in relatively deep water and still reach the sunny surface layers, buoyed up by the gas-filled pneumatocysts at the base of each frond. It grows quickly too – nearly half a metre (half a yard) a day in ideal conditions. As with its terrestrial equivalents, a kelp forest is structurally complex, providing a multitude of habitats for a plethora of other species. Here, blue rockfish – one of at least 10 species of rockfish often seen in the Monterey kelp forests – navigate the upper layers, their colours shimmering in shafts of light breaking through the canopy. It's a photograph that captures that sense of immersion in the waters of this diverse and species-rich sanctuary.

Nikon D850 + 16-35mm f4 lens; 1/30 at f11; ISO 640; Nauticam NA-D850 housing; 2x Sea & Sea YS-D2J strobes.

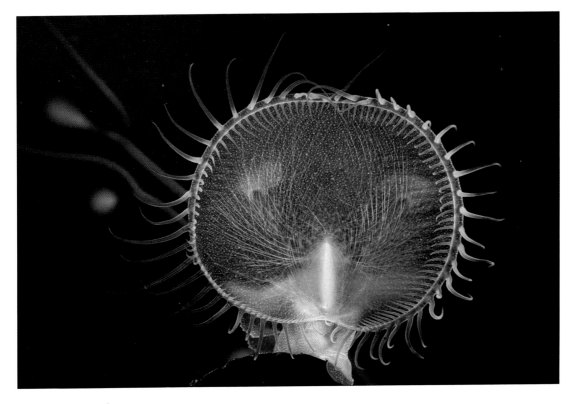

Mane attraction

From its perch on a kelp frond, a lion's mane nudibranch wafts its
tentacle-fringed mouthparts through the water in search of food. Most
nudibranchs – shell-less marine snails that are a subgroup of sea slugs
– scrape encrusting animals such as sponges and sea squirts from rocks
and vegetation with an abrasive, tongue-like radula. But the lion's mane
does things very differently. It trawls for free-swimming crustaceans and
other invertebrates using an expandable hood that encircles its mouth.
On contacting prey, the hood closes around it like a Venus flytrap, its
tentacles blocking the victim's escape while excess water is expelled. Then
it is swallowed whole. According to staff at the Monterey Bay Aquarium, a
lion's mane nudibranch smells of watermelon. The function of this odour
is not known, but it might be to repel predators or attract mates.

**Nikon D850 + 60mm f2.8 lens; 1/160 at f14; ISO 250; Nauticam NA–D850 housing;
2x Sea & Sea YS–D2J strobes.**

In a different light

Moments of tranquillity are precious in an ecosystem so exposed to the raw power of wind and waves. A calm, sunny day at Monastery Beach, just south of Monterey Bay, gave Sage the chance to get closer to the kelp he knows so well, without having to constantly fight for position against the swell. While exploring how natural light from above plays on the kelp's finer details, he caught this fleeting moment when a sunbeam, refracted by the water, picked out the serrated edges of the fronds in rainbow colours. Biologists also have started seeing seaweed in a new light – some seaweeds, including kelp, are classified as brown algae, and used to be classed with plants. However, they are more closely related to the single-celled diatoms than they are to the other seaweed groups. Research analyzing the evolutionary history of the brown algae suggests they diverged during the Mesozoic Era – better known as the time of the dinosaurs.

Nikon D850 + 60mm f2.8 lens; 1/160 at f10; ISO 1000; Nauticam NA-D850 housing; 2x Sea & Sea YS-D2J strobes.

The Young Wildlife Photographer of the Year 2024 Award

This year's grand-title is awarded to Alexis Tinker-Tsavalas, who is also the winner of the category for young photographers aged 15-17 years. Alex's picture has been judged to be the most memorable of all the entries by photographers aged 17 or under.

Life under dead wood

Alexis Tinker-Tsavalas

GERMANY

Alexis specializes in subjects smaller than his thumbnail and often scans the forest floor in autumn, alert for tiny movements or intriguing forms. Carefully rolling over a log in his local forest in Berlin, he saw a patch of mottled spheres on stalks and recognized them as the fruiting bodies of slime mould. Among them he spotted a springtail, barely two millimetres long (less than a tenth of an inch). Slime moulds look like fungi but are eukaryotic organisms that closely resemble amoeba, with 900 known species in diverse colours and shapes. Both springtails and slime moulds are found all over the world in leaf-litter, feeding on micro-organisms such as bacteria and fungi, improving soil by helping organic matter to decompose. Springtails can jump many times their body length in a split second, so Alexis had to work fast. Using a technique known as focus stacking, he took 36 images – each with a different area in focus – and combined them later into this single image.

Panasonic Lumix G91 + Laowa 25mm f2.8 2.5-5x ultra macro lens; 1/200 at f4; ISO 200; Nikon SB-900 Speedlight flash; Cygnustech macro diffuser; focus stack of 36 images.

You don't have to travel far to find incredible subjects. I can just imagine the young photographer exploring in the forest, peering under rocks and logs for hidden treasure. Using the technique of focus stacking was a brilliant choice for these diminutive subjects, bringing rarely seen subjects into sharp focus for the world to appreciate.

Tony Wu

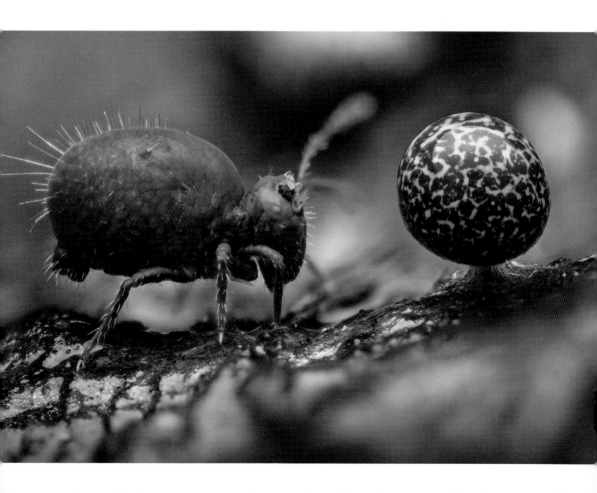

What a masterpiece of capture – lit like a Caravaggio painting. Of course, luck was involved, but this knowledgeable young naturalist knew how to make his luck – where to be and when, and how to catch and frame that precious sunbeam moment of illumination.

Roz Kidman Cox

An evening meal

Parham Pourahmad

USA

The last rays of the setting sun illuminate the face of a young chicken hawk and that of its evening meal, a ground squirrel, which the hawk's industrious mother caught and killed in a woodland in the heart of California's Silicon Valley. Over the course of a single summer, Parham visited Ed R. Levin County Park, in the San Jose suburb of Milpitas, taking photos most weekends to showcase the variety of wildlife that lives within the precincts of a busy city. The female hawk brought in a regular supply of small mammals and birds to raise and fledge a brood of four chicks. Parham believes she raised her brood without much help from her partner, as he never saw the male during any of his visits. Part of the skill behind getting this shot was to gain the trust of these wary raptors, so they would accept the presence of Parham and other photographers who were watching from a respectful distance. The chicken hawk is a common species across southern Canada, the USA and into central Mexico, inhabiting mature and open woodlands and, increasingly, urban areas where there are tall trees for nesting. Indeed, Parham sees the hawks regularly in his own back garden. With a wingspan of up to 90 centimetres (36 inches), a chicken hawk is a little larger than a Eurasian sparrowhawk. As with many birds of prey, they exhibit extreme sexual dimorphism, meaning the female hawk is up to one third larger than the male. They hunt by stealth, using dense cover to ambush their prey before a burst of speed takes the prey by surprise, as was the case with this squirrel.

Nikon D3500 + Sigma 150-600mm f5-6.3 lens at 210mm; 1/400 at f6.3; ISO 800.

For such a young photographer, Alberto has a strong eye for composition, and this is what stands out above all else. Many experienced wildlife photographers often shun the idea of including human-made objects in their shot, but here they form a beautiful framework for the bird and add context to its suburban habitat.

Chien Lee

Free as a bird

Alberto Román Gómez

SPAIN

Watching from the window of his father's car, Alberto saw this juvenile stonechat perching on a fence and then repeatedly dropping to the ground to snatch small insects. He'd come looking for birds to photograph in the countryside at the edge of the Sierra de Grazalema Natural Park in southern Spain. Together, father and son searched guidebooks and looked online to identify this European stonechat, as the juvenile hadn't yet developed its distinctive adult plumage, nor did they hear the *'tchak'* call – like two stones tapped together. Sierra de Grazalema covers a large area in the Andalusian provinces of Cadiz and Malaga, with mountain ranges, cliffs, caves and forests as well as towns such as Ubrique, Alberto's home. There are very few trees at this edge of the park, so birds take advantage of the fences that separate private lands. European stonechats prefer open habitats and typically perch on bushes, gates or fences, from which they look out for insects on the ground. This one was tricky to photograph as it was going back and forth so fast. It only landed beside the padlock a few times but Alberto, who has been taking photos since he was four years old, was ready to capture the moment that it paused for a second, showing the contrast between the hefty chain and the delicate bird. The summer light emphasized the echoes of colour between the rusty metal, the bird's plumage and the dry grassland beyond. To Alberto, the stonechat portrayed a sense of ownership – like a young guardian overseeing its territory.

Olympus OM-D E-M1 Mark III + 100-400mm f5.6-6.3 lens at 400mm; 1/640 at f6.3 (+1 e/v).

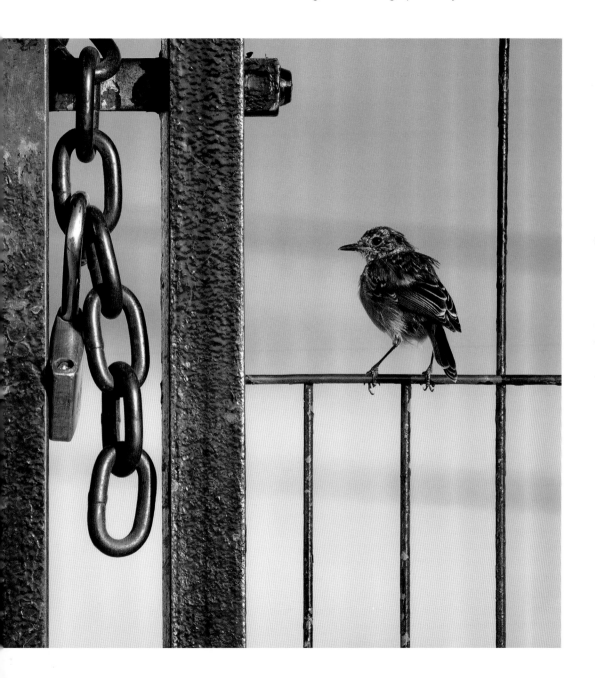

People's Choice

Only 100 competition images can be selected, but many more deserve to be seen. A further 25 unforgettable photographs from this year's entries have been chosen by the jury and the Natural History Museum.

Curious connection

Nora Milligan

USA

Trekking through the forest of Loango National Park, Gabon, Nora's guide signalled for the group to stop near the bank of a swamp. As they crouched down, they first heard the call of a chimp before the leaves around them started to rustle and a group of chimpanzees moved across the dark forest floor. This family is known as the Rekambo group and is being studied by researchers from the Ozouga Chimpanzee Project. Thrilled to even catch a glimpse of the wild great apes, Nora couldn't believe her luck when they started to ascend the nearby trees. As she peered through her viewfinder, a large male paused and looked down at them. The chimp craned his neck forward and his eyes seemed to widen, as if to get a better look. It was such a human movement that Nora stopped for a moment and just stared right back at him.

Nikon D850 + 300mm f2.8 lens; 1/640 at f3.2; ISO 2500.

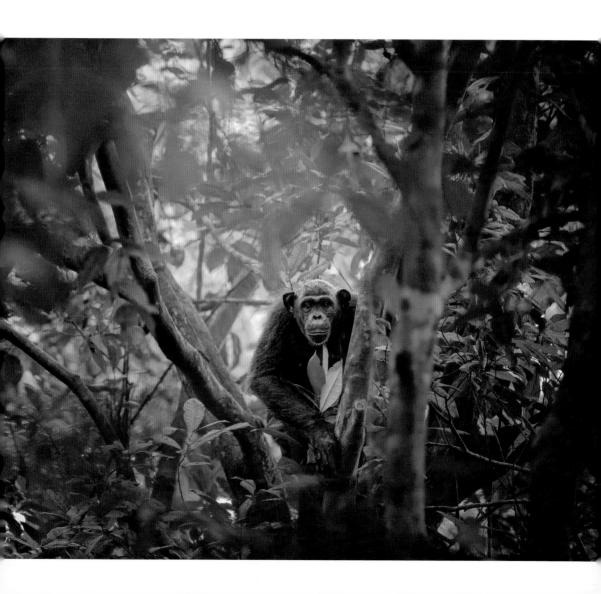

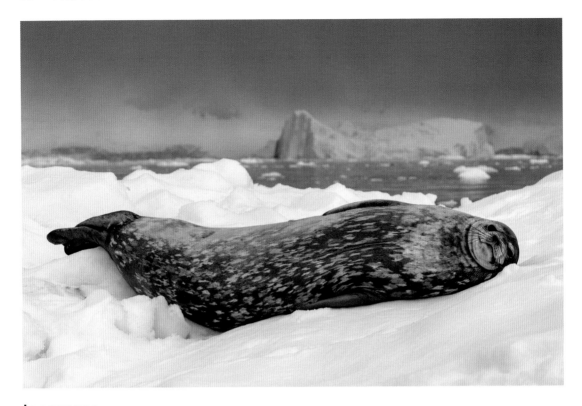

Icy repose

Sue Flood

UK

From aboard a rigid inflatable boat, Sue observed this Weddell seal as it was relaxing on an ice floe in Neko Harbour, Andvord Bay in the Antarctic Peninsula. The dramatic blue-grey of the sky highlighted the soft greys in the beautiful pelt of this deep-diving pinniped. Using a long lens so as not to disturb its peaceful slumber, Sue captured this serene portrait. Weddell seals' large bodies are covered in a thick layer of blubber to keep them warm above and below the icy waters of the Southern Ocean.

Canon R5 + 100–500mm f4.5–7.1 lens; 1/640 at f7.1; ISO 160.

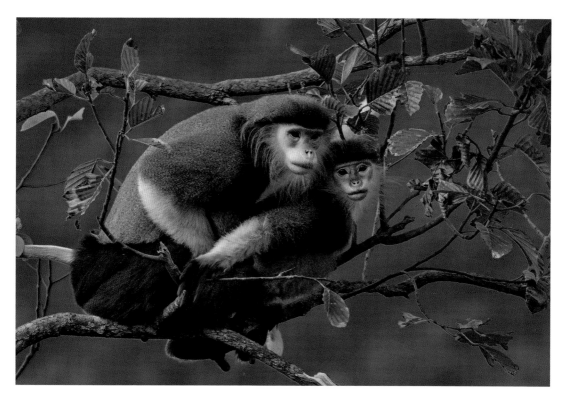

Togetherness

Ivan Ivanek

CZECH REPUBLIC

These striking primates are found only in Vietnam, Laos and Cambodia, and are distinguished by their bright red 'stockings'. Ivan was in central Vietnam, where a population of red-shanked douc langur lives on the forested Son Tra Peninsula. After days of observing the area looking for evidence of the monkeys, he managed to find a small group and set about watching it. Late one evening he witnessed these two individuals mating – an unexpectedly more gradual and graceful affair than other species of monkey he'd seen mating. The species is critically endangered due to loss of habitat, hunting and the illegal pet trade.

Fujifilm X-H2 + 150–600mm f5.6–8 lens; 1/210 at f7.1 (–0.7ev); ISO 2000.

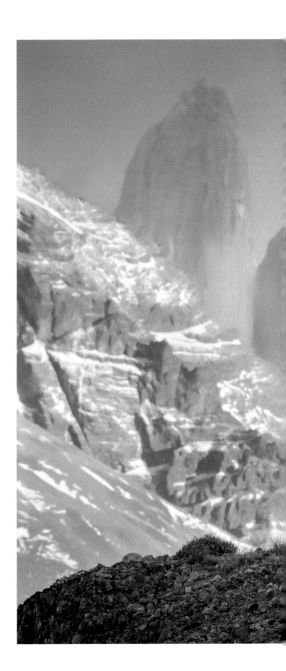

Scanning the realm

Aaron Baggenstos

USA

In the rugged terrain of Torres del Paine, Chile, a puma stands sentinel atop a windswept outcrop. She is a symbol of hope and is part of a successful conservation movement that has seen the creation of the Torres del Paine National Park and the rise of ecotourism. Education about the benefits of wildlife conservation, and the realization that pumas can attract tourism, thus providing a sustainable source of income, has helped local gauchos (sheep farmers) rethink their relationships with the pumas – turning the gauchos away from hunting them. The introduction of sheepdogs has helped mitigate conflicts – the dogs are fiercely protective of the flock and when a puma approaches, they confront the predator, deterring it from attacking the sheep. This encourages the pumas to hunt their natural prey and stops the gauchos from shooting them. This change has been gradual, but has gained momentum over the past 20 to 30 years and is proof that humans and pumas can happily coexist.

Sony α1 + 70–200mm f2.8 lens; 1/320 at f13; ISO 2500.

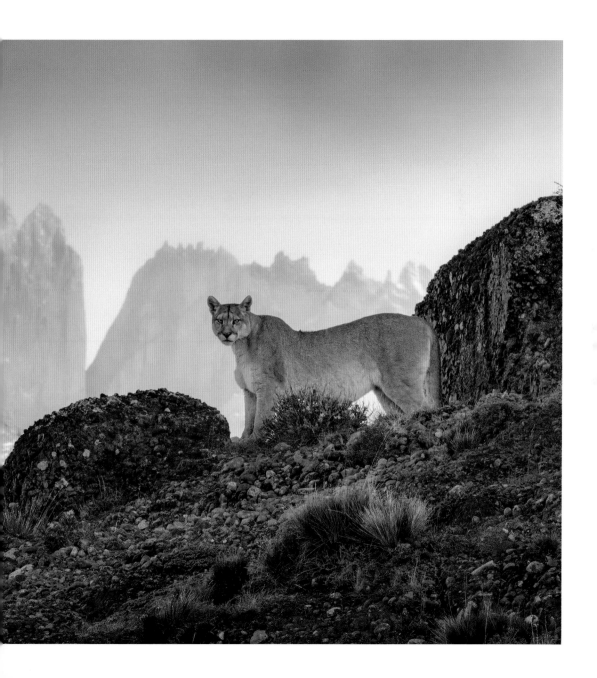

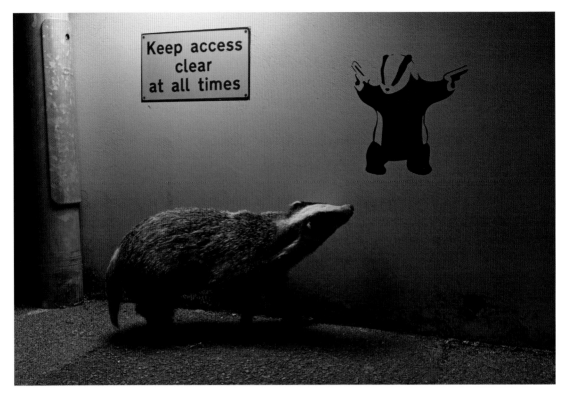

No access

Ian Wood

UK

In some urban areas, Eurasian badgers live in close proximity to humans. This picture was taken on a quiet road in St Leonards-on-Sea, East Sussex, England. Ian noticed residents were leaving scraps out on the pavement for foxes, but badgers from a sett close by were also coming to forage. After witnessing a badger walking along the pavement by this wall late one night, he decided to photograph it and set up a small hide on the edge of the road. Only the light from a lamppost illuminated the creature as it ambled along, seemingly glancing up at the badger graffiti just in front of it.

Nikon D500 + 18–35mm f3.5 lens; 1/100 at f9; ISO 2500.

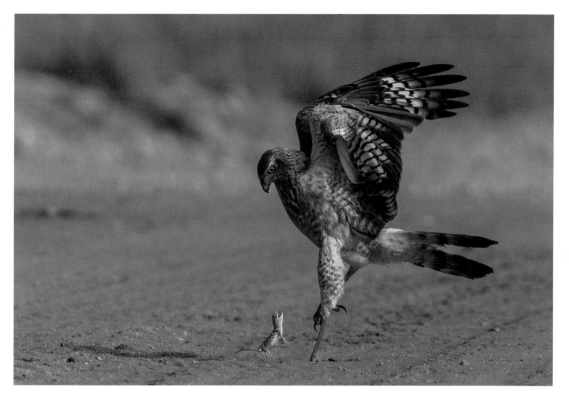

The brave gecko

Willie Burger van Schalkwyk

SOUTH AFRICA

One hunting strategy of the southern pale chanting goshawk is to walk or run on the ground in pursuit of prey. Here, in the Kgalagadi Transfrontier Park, South Africa, a juvenile bird is facing resistance from a giant ground gecko. Willie watched as the little lizard put up a brave fight against its large aggressor, jumping up at it as photographed here. Unfortunately, there was only one possible outcome, but Willie felt strongly that such bravery should have resulted in a different outcome for the brave gecko.

Canon R5 + 500mm f4 lens + 1.4x teleconverter; 1/1600 at f8 (-0.33ev); ISO 250.

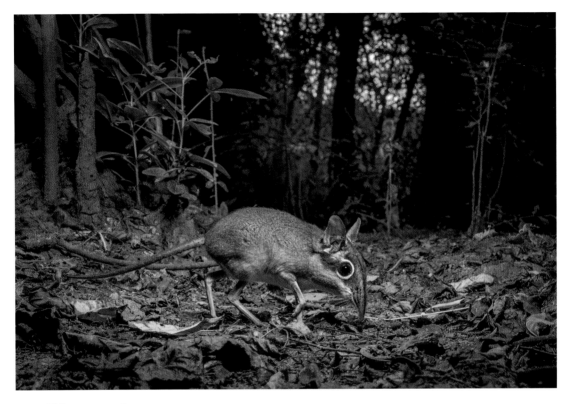

Snuffling sengi

Piotr Naskrecki

POLAND

One of Africa's least-known inhabitants is the rarely seen four-toed sengi. Sengis are mostly insectivorous and look for their prey at dusk and dawn. Over several weeks, Piotr watched this individual follow the same network of trails every day, looking for beetles and other tasty morsels among the leaf litter. Sengis rely on a combination of good vision and excellent sense of smell to find food. Sengis are extremely shy and skittish, so Piotr set up a remote camera that allowed him to photograph the little creature sniffing for food in Gorongosa National Park, Mozambique.

Sony α6400 + 40mm f2.8 lens; 4x Nikon SB28 Speedlights; Cognisys Scout PIR sensor.

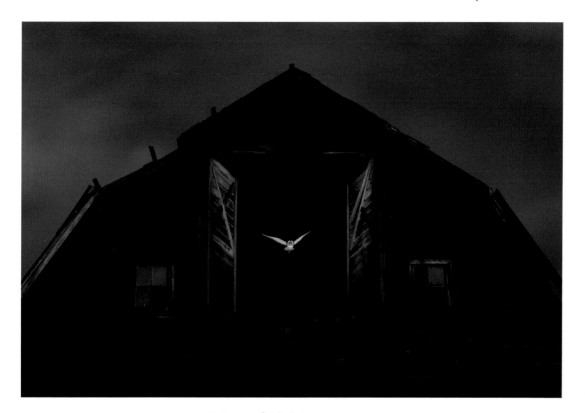

Edge of night

Jess Findlay

CANADA

As darkness sets in, a ghostly barn owl exits the hayloft window of a derelict barn to begin its nightly hunt in an agricultural area just outside Vancouver, Canada. After several nights quietly watching, Jess began to understand the habits of this individual and what was needed to record this fleeting moment. He set up an invisible beam over the exit and, as the owl flew out of the barn, it triggered the flash. Jess's camera ran a time-lapse of long exposures, capturing ambient light cast upon the clouds and barn exterior. To his amazement, the very first time the owl passed through, all parts functioned as he'd imagined.

Canon EOS 5D Mark III + 100-400mm f4.5-5.6 lens; 30 sec at f7.1; ISO 1000; Canon Speedlite 600EX II-RT; Cognisys Sabre sensor.

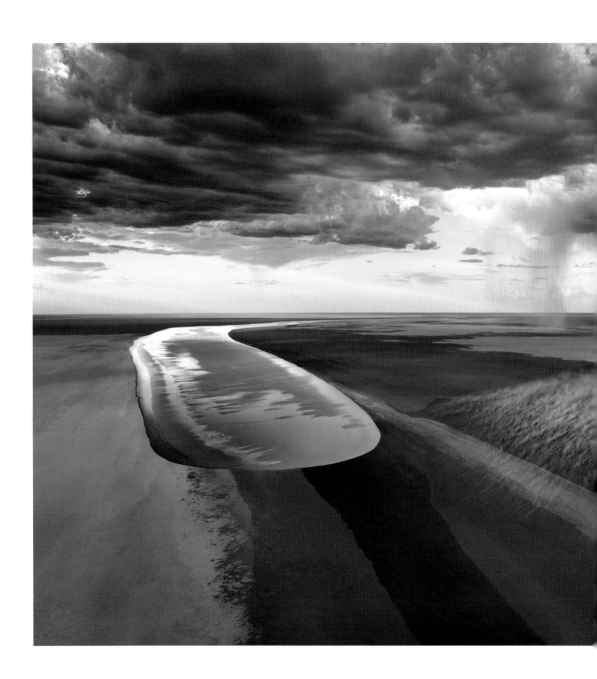

The arrival

Brad Leue

AUSTRALIA

Photographing from a helicopter in strong winds was quite a challenge for Brad, but with a scene such as this unfolding in front of him, it was easy to stay focused. Floodwaters were travelling through the desert, a dust storm was blowing to the right and rain was falling on the horizon, so timing was imperative to photograph this once-in-a-decade natural event. Floodwaters have travelled more than 1,000 km (1,600 miles) from southwest and central Queensland, surging steadily towards South Australia and the shores of Kati Thanda-Lake Eyre – Australia's largest inland lake and one of the world's largest salt lakes. This image shows the water channeling steadily down Warburton Groove, the final stretch before entering the mighty Kati Thanda-Lake Eyre. On their journey, the waters bring new life to this remarkable desert system and the rare and threatened wildlife that calls it home.

Canon EOS-1D X Mark II + 24-70mm f2.8 lens; 1/640 at f9; ISO 500.

Whiteout

Michel d'Oultremont

BELGIUM

Michel had been looking for stoats in the snow for many years. He'd seen a few in Switzerland but never in his native Belgium – then, finally his dream came true. Lying in the snow with a white camouflage net covering all but his lens, he watched the little balls of fluff in the white landscape. The magic of snow and white fascinates Michel every winter, and he wanted to photograph the whiteness of the landscape and the stoats' ability to blend in with it. This curious one came out of its snowy hole and sat up from time to time, observing its territory just before setting off to hunt.

Canon EOS R5 + 400mm f2.8 lens; 1/1600 at f4; ISO 1250.

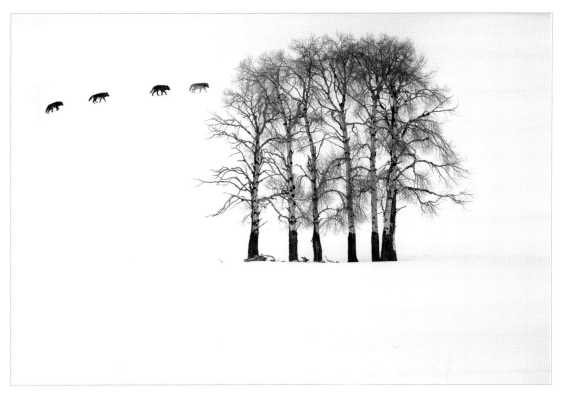

Aspen shadows

Devon Pradhuman

USA

Four grey wolves traverse the snowy landscape of Yellowstone National Park, USA, their presence echoing through the minimalist beauty of aspen trees and snow. It was early spring in the Lamar Valley and this pack was in search of its next meal. Watching from a distance, Devon was looking for a unique composition, given the wolves were small in their landscape. Seeing them heading towards this patch of aspens, he thought it might make for a compelling image. Sure enough, they walked right past these trees and then continued to follow the tree line until they disappeared over the hillside.

Canon EOS 5D Mark IV + 500mm f4 lens + 1.4x teleconverter; 1/800 at f5.6; ISO 200.

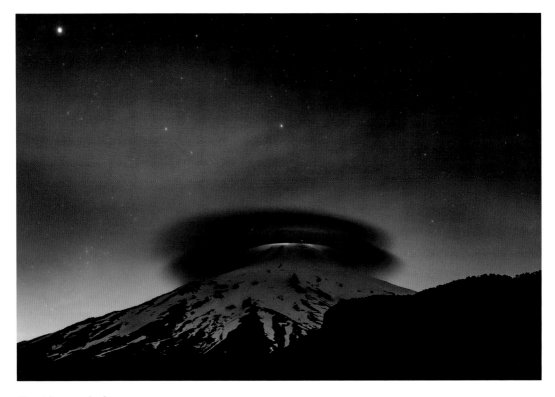

Earth and sky

Francisco Negroni

CHILE

Taken at nightfall, a beautiful double lenticular cloud is illuminated by the lava emitted by Villarrica volcano. Located in the town of Pucón in the south of Chile, Villarrica is one of the country's most active volcanoes, last erupting in 2015. Francisco takes regular trips to Villarrica to monitor its activity, describing every trip as 'quite an adventure – never knowing what the volcano might surprise you with'. Some nights are calm, others furious as in this photograph, where the brightness of the crater illuminates the night sky. To document this, he stayed nearby for 10 nights and, on one of those nights, the volcano and nature gave him this image.

Nikon D600 + 50mm f1.4 lens; 30 sec at f3.3; ISO 100.

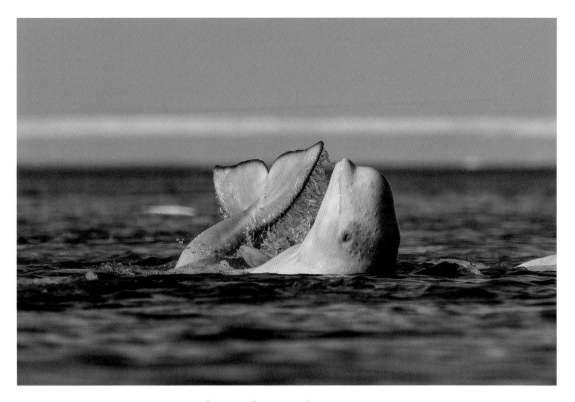

A good scratch

Mark Williams

UK/CANADA

Mark took this image in a remote inlet along the Northwest Passage in the Canadian Arctic, where hundreds of beluga whales come to socialize and exfoliate their skin in the shallow water. The passage is also a safe haven, away from the predatory orcas. Belugas are extremely sociable mammals – they live, hunt and migrate together in pods that can range from quite small into the hundreds. In this image, the whale is rubbing its underside on the shallow river bottom. Nicknamed 'the canaries of the sea' they produce a series of chirps, clicks, whistles and squeals and Mark found the vocals otherworldly.

Canon R5 + 100-500mm f4.5-7.1 lens; 1/3200 at f7.1; ISO 400.

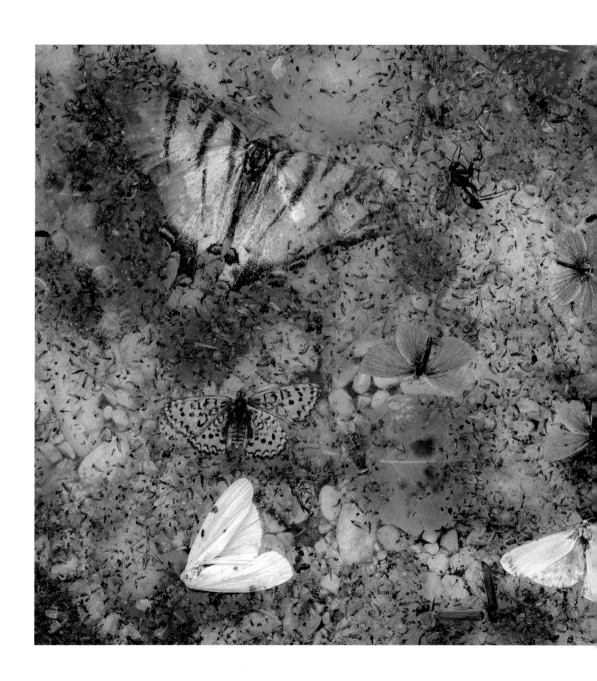

Fallen from the sky

Carlo D'Aurizio

ITALY

As often happens, we go out to photograph a subject but something unexpected presents itself to us. It was a summer morning in the San Bartolomeo valley, in the Majella National Park, Italy. It had not been particularly hot and there hadn't been any storms in the previous days, and Carlo expected to witness the graceful flight of butterflies and dragonflies along the course of the small stream that he had frequented many times. He never thought he would find such a still life, a sad collage of dead insects calmly floating in the water. To this day he still has no explanation of why the insects died.

Sony α7R IV + 90mm f2.8 lens; 0.8 at f13; ISO 100.

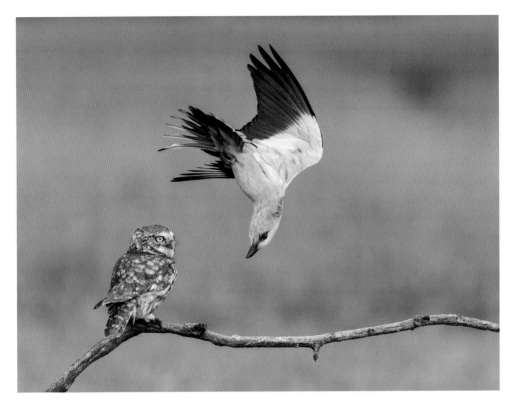

Annoying neighbour

Bence Máté

HUNGARY

The little owl and the European roller are very different birds but, because their nests and feeding requirements are very similar, they sometimes breed in close proximity. The male roller makes a sport of annoying other birds, flying at full speed behind them, opting for a surprise ambush, no matter how big or small, of those that stray into its breeding area during the short mating season. The little owl seemed nonplussed by the spectacle. To catch such an extremely fleeting and rare scene, Bence, on constant alert, spent 27 days watching from a hide in Kiskunsag National Park, Hungary.

Canon EOS R5 + 200mm lens; 1/5000 at f2.8; ISO 2500.

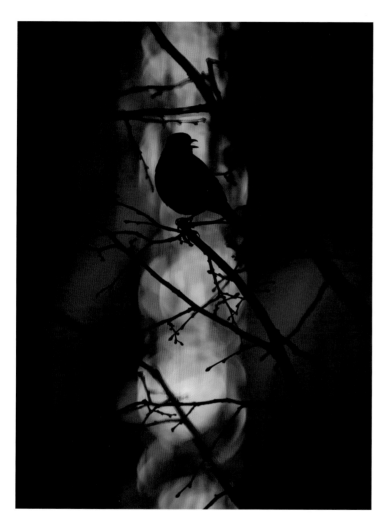

Evening song

Christian Brinkmann
GERMANY

The evening mood was gentle, and Christian had singing birds on one side and party music on the other. During the Send (a spring fair in his hometown), an interesting atmosphere arose behind the castle in Münster, Germany. In front of the fairground lights, this Eurasian blackbird posed for its song. Although blackbirds are a pretty common sight, Christian really likes to photograph them in distinctive ways, such as in this picture – the silhouette of the bird set against a colourful backdrop, giving the image an artistic flair.

Nikon Z9 + 400mm f2.8 lens; 1/250 at f4 (–2ev); ISO 2200.

Unsold

Jose Fragozo

PORTUGAL

Scared and confused, this very young female cheetah cub hisses at her new surroundings. Captured from her home plains in the Somali Region, eastern Ethiopia, she was transported for several days on the back of a camel to the northern coast of Somaliland, part of the trade of illegal wildlife trafficking monitored by the Environmental Protection and Rural Land Administration Bureau. The Somali Region is extremely poor and farmers catch and sell cheetah cubs to traffickers, claiming that the cheetahs attack their livestock. Sometimes the farmers and traffickers are not able to sell the cubs immediately, so they keep on growing and eventually become juveniles and adults, making it more and more difficult to find buyers. Some end up being killed and their parts sold, their bones shipped to Yemen and then to other Asian markets where they are sold as tiger bones and used to make Chinese bone wine. After hissing at the camera, the cub started chirping, calling out for its mother.

Canon EOS R5 + 35mm f1.4 lens; 1/500 at f7.1; ISO 100.

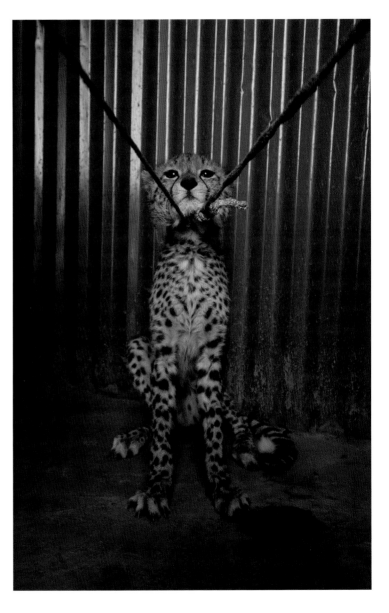

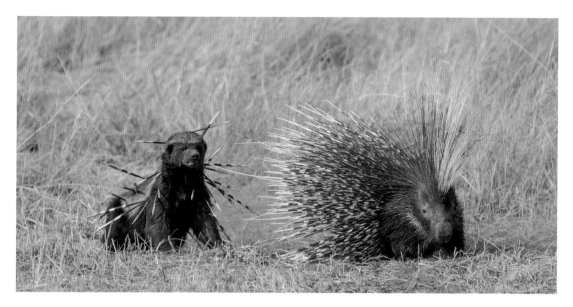

Spiked

David Northall

UK

Found throughout Botswana, honey badgers are known to have a
ferocious reputation and often chase animals many times their own
size. This honey badger got an unpleasant surprise when it found and
attacked this Cape porcupine (normally a nocturnal creature). The
badger grabbed the porcupine's back right leg and the porcupine, in
defence, repeatedly backed into its attacker, piercing it with many quills,
before managing to shuffle away during a lull in the attack, its leg badly
damaged. After a short retreat, and despite the many embedded quills,
the bloodied badger returned and ultimately won its prize, finishing the
porcupine off under a bush close to the original attack, before dragging
it into its underground den.

Nikon Z9 + 100–400mm f5.5 lens at 400mm; 1/2000 at f5.5; ISO 360.

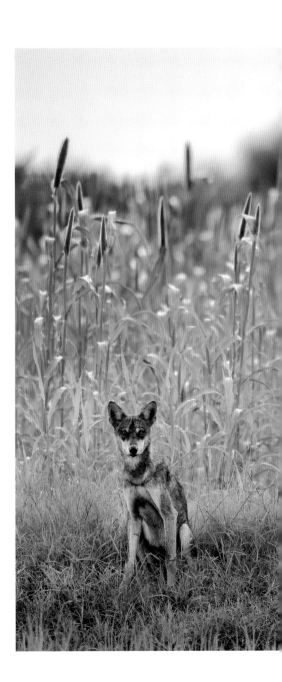

Wolf pack

Arvind Ramamurthy

INDIA

Indian wolves were once found all across India. Now, their number has dwindled to as low as 3,000. Their habitat of rolling grasslands has become fragmented by agricultural fields and, although the wolves have adapted to living among humans, their habit of feeding on cattle carcasses puts them at risk of disease. For their populations to thrive, grasslands need better management, restoration and protection. With a little better protection, this hardy animal can make a strong comeback in the country. This pack was playing in the grassy fields and Arvind was photographing the animals in action when one of them came and sat down at the edge of the agricultural crop. One by one they followed, until five of the wolves paused for a few seconds before they ran off again, playing with and chasing one another.

Nikon Z9 + 400mm f2.8 lens; 1/10,000 at f2.8 (-0.3ev); ISO 2500.

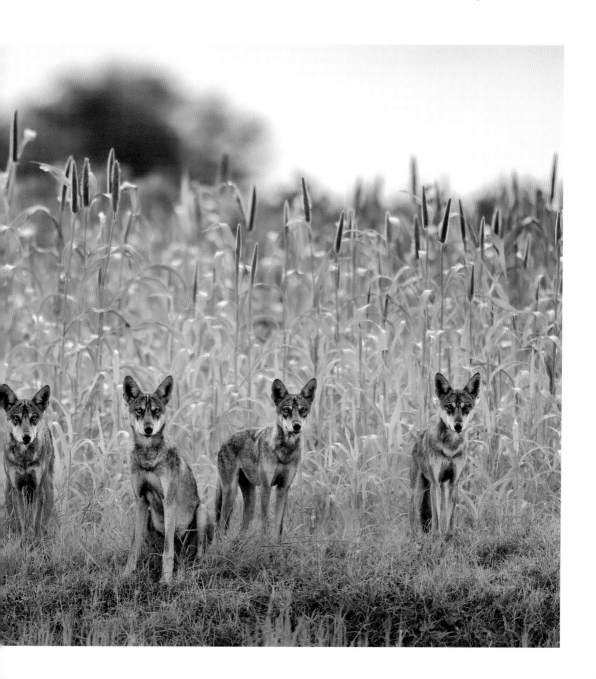

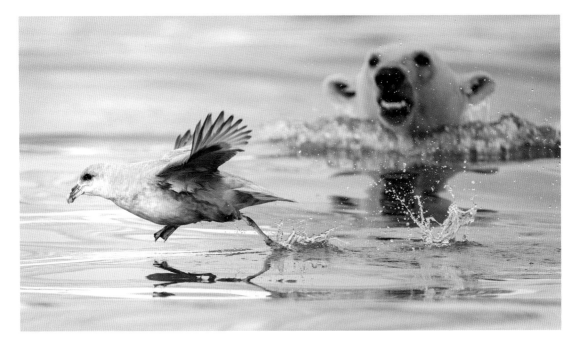

Sneak attack

Erlend Haarberg

NORWAY

In the Norwegian archipelago of Svalbard, a walrus carcass had attracted a female polar bear and her two cubs. But one of the cubs was more interested in playing in the water than eating. The cub was having fun diving under the water and resurfacing, playing with the seaweed and kelp. The northern fulmar resting on the surface of the water awakened the cub's desire to hunt. Erlend watched as it attempted several underwater surprise attacks on the bird, only to fail each time. Play hunting like this is essential learning for a young bear, as eventually it will have to survive in the Arctic without its mother.

Nikon Z9 + 180–400mm f4 lens; 1/2500 at f5.6; ISO 1000.

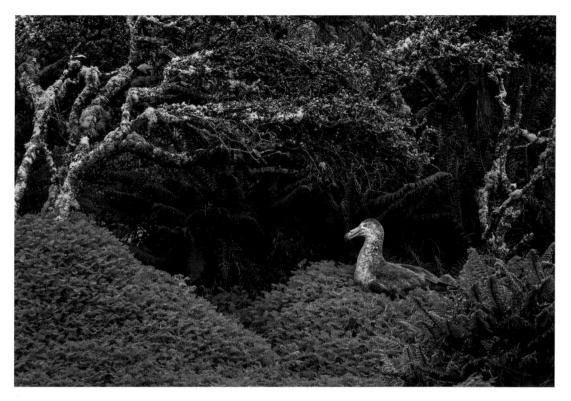

Forest of dreams

Samuel Bloch
FRANCE

Northern giant petrels are large seabirds and normally, when we think of them, we imagine them flying above the waves, not encountering any land for weeks on end. So Samuel was quite surprised to come across this one in such a woody environment, sitting on a nest at the edge of the rātā forest of Enderby Island, New Zealand. As with many seabirds, it breeds on islands where there are fewer predators. This image was taken from a distance and Samuel left quickly to minimize any disturbance.

Canon EOS 7D Mark II + 100–400mm f4.5-5.6 lens at 400mm; 1/640 at f6.3; ISO 1000.

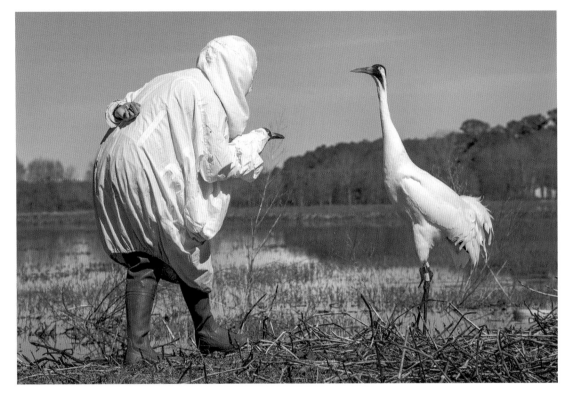

Meeting in the marsh

Michael Forsberg

USA

Michael has been chronicling the lives of endangered whooping cranes since early 2019. Here, a costumed crane biologist approaches a crane and, with cat-like quickness, captures it by hand to conduct a health check and change a transmitter that is no longer working. The transmitter helps biologists track the birds and learn more about the lives of this non-migratory population. This experimental Louisiana population was reintroduced in 2011 after a 61-year absence of whooping cranes in Bayou Country, USA. After a low of roughly 20 birds in the 1940s, whooping crane numbers have climbed to over 800 in both wild and captive populations and are a conservation success story.

Sony α1 + 70-200mm f2.8 lens; 1/1250 at f11; ISO 400.

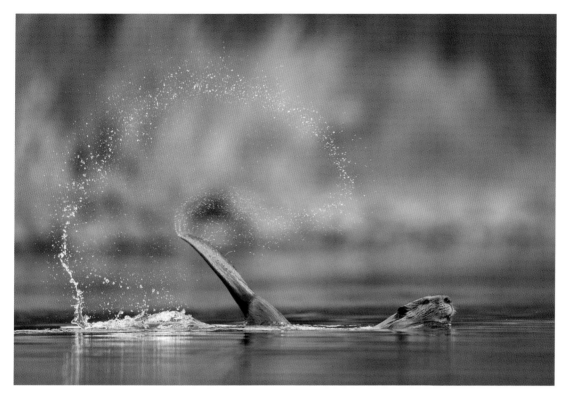

Slap shot

Savannah Rose

USA

In the hope of finding wildlife surrounded by beautiful autumnal colours, Savannah visited a pond she enjoys frequenting to photograph North American beavers in Jackson, Wyoming, USA. As she approached the shoreline, a beaver cruised cautiously by after emerging from its lodge, cocked its tail up and brought it down with a resounding crack. This is an image Savannah has been trying to perfect for several years, to document one of the most dramatic beaver behaviours among its wetland habitat. Beavers use tail smacks to alert their family group to a newcomer to their pond. Despite the theatrics, beavers usually relax quickly after discovering the newcomer doesn't pose a threat.

Nikon Z9 + 400mm f2.8 lens; 1/2000 at f2.8; ISO 1000.

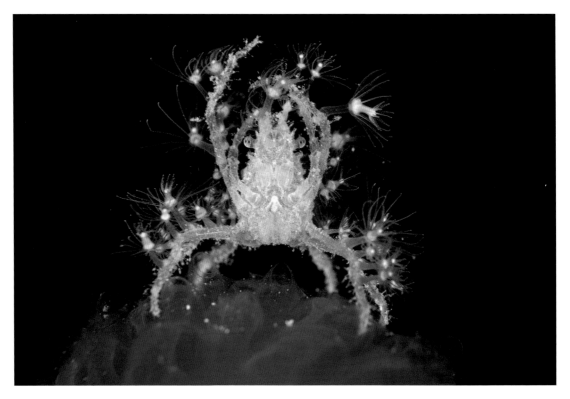

Drifting dinner

Noam Kortler

ISRAEL

Noam took this photograph during a night dive off Komodo island, Indonesia. The decorator crab was perched on a sea squirt, elevating it from the bottom of the ocean so it had the perfect stage to feed on drifting plankton. The crab has camouflaged and armed itself with tiny hydroids known as *Tubularia*. These are known to sting other animals and so help protect the crab from would-be predators. Illuminated by the camera flash, as if in a spotlight centre stage, the crab gracefully searched for food while Noam watched.

Nikon D850 + 60mm f2.8 macro lens; 1/100 at f20; ISO 200; Seacam housing; Scubalamp D-Pro strobe; snoot.

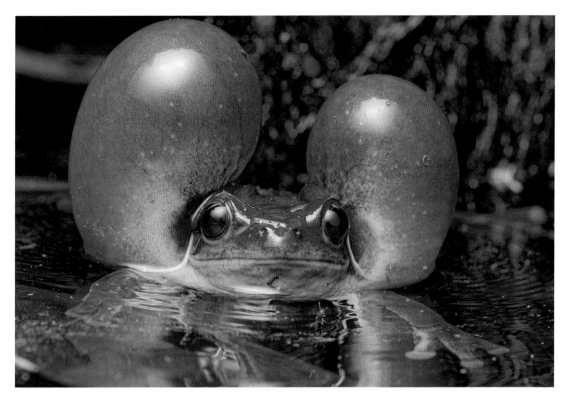

Concert in the forest

Vincent Premel

FRANCE

The first rains come in French Guiana after a long dry spell, and they are a release for all wildlife, but especially for amphibians. The ponds fill with water and dozens of species descend from the canopy or come out of the ground to lay their eggs in the water, in a event called 'explosive breeding'. The density of individuals is hard to imagine and made for a special night for Vincent, who is both a herpetologist and photographer. This Surinam golden-eyed tree frog puffs out his cheeks as he prepares to call for a mate – the call is so powerful it can be heard hundreds of metres away.

Sony α7 III + 90mm f2.8 lens; 1/80 at f11; ISO 400; Neewer flash; homemade flash diffuser.

Index

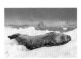
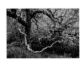

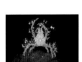
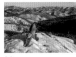

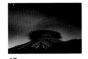

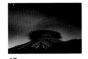
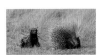
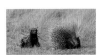

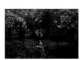

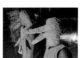
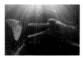
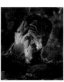

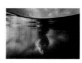
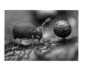
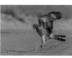
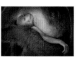